The Anatomy of a House

A Picture Dictionary
of Architectural and
Design Elements

FAYAL GREENE

Illustrations by
BONITA BAVETTA

DOUBLEDAY
New York London Toronto Sydney Auckland

PUBLISHED BY DOUBLEDAY
a division of Bantam Doubleday Dell
Publishing Group, Inc.
666 Fifth Avenue, New York, New York 10103

DOUBLEDAY and the portrayal of an anchor with a dolphin
are trademarks of Doubleday,
a division of Bantam Doubleday Dell
Publishing Group, Inc.

Library of Congress Cataloging-in-Publication Data

Greene, Fayal.
 Anatomy of a house: a picture dictionary of
architectural and design elements / Fayal Greene:
illustrations by Bonita Bavetta.—1st ed.
 p. cm.
 Includes bibliographical references.
 1. Architecture—Details—Dictionaries. 2. Architecture,
Domestic—Dictionaries. 3. Picture dictionaries. I. Title.
NA2840.G74 1991
728—dc20 90-43120
 CIP

ISBN 0-385-41242-8

Table of Contents

Introduction

WE'RE a house-proud people. Each year we spend more than a hundred *billion* dollars improving our homes. We add family rooms, renovate kitchens, update baths, and improve existing space with new windows and fireplaces. Besides money, all of this construction takes enormous amounts of time and effort. Although most people are happy with the results, some complaints are unfortunately common. This book is for homeowners and professionals alike, to make those complaints a rarer occurrence.

After enduring months of work and mess, homeowners can be disappointed in the finished renovation. "It doesn't look the way I expected," they say. Somehow, the mental picture they saw so clearly has not been brought to life.

The decorator or designer, architect or contractor, is blamed for this sad state of affairs. Isn't it the responsibility of the professional to make that translation from dream to reality? Yes, but—even the best translator needs a dictionary.

I've rebuilt eight houses for myself and my family, often acting as general contractor, and I can empathize with both sides. All of those homes were attractive and comfortable to live in, but in each case there were things I wish I had done differently and better. Thinking about the problem over the years, I've come to the conclusion that two factors cause most of the trouble: *choice* and *communication*. And that's what this book is about.

Choice can bewilder even an experienced renovator or builder. Do you want sash or casement windows? Paned or plate glass? Paneled or flush doors? How many panes? What shape panels? Cornice moldings and doorframes—what style and how big? And on and on . . . and on. Local lumberyards and hardware stores have a large choice of sizes and styles. Specialty suppliers have even more, and custom workshops can make anything they lack. So you can get whatever you want, but how do you know what you want? Use this book to find out.

The Anatomy of a House is made up of hundreds of drawings of the individual parts of a house. Find the chapter on the item you need. If the picture isn't precisely the window or baluster you had in mind, you'll find it easier to describe by comparison ("Like this but with four panes in each row instead of three" or

"Like this but with another curve at the top") than having to start from scratch. Which brings us to *communication*.

The professional, whether designer or contractor, is in business to make your vision a reality. Some homeowners like simply to imagine a style or atmosphere, letting the architect or decorator choose the specific details that create the style. But most clients want to be more intimately involved in the creative process. After making your choices, you try to describe them but may not have the vocabulary to portray your ideas accurately. The professional then takes on the role of detective, trying to re-create your mental picture from your clues. Some are better detectives than others, but almost all cases call for a lot of guesswork.

Professionals often try to avoid guesswork by supplying drawings of the project. These can help, but the most frequently heard complaint from designers and architects is "I gave them drawings of every stage and every change order, they initialed each one, and *still* they aren't happy with the result!" The fact is, few nonprofessionals can look at a complex drawing of a wall or an entire room with enough assurance to identify each element and make the changes they want.

This book identifies each element of the house separately. It is a *picture dictionary* establishing a common language for the professional and the client. They can pick out, for instance, individual doors, skylights, or molding shapes for discussion, without the complexity of a full drawing. That increased communication should help prevent disappointment and frustration on both sides.

There is no greater satisfaction than improving a home so that it looks better and works better. It's a job well done for the professional and a constant pleasure for the homeowner. *The Anatomy of a House* was created to give you that satisfaction.

Acknowledgments

THANKS are due to all the professionals, especially architects Nancy and John Beringer and decorators Lynn Jacobson and Arnold Copper, who gave me the benefit of their thoughts as this book was taking shape. Gratitude, too, to fellow guests at various dinner parties who told their tales of renovation joy and frustration. Carol Sana Sheehan and the staff of *Decorating Remodeling* participated in the early "anatomies" in that magazine; Lisa Walker assembled the Directory. Denise Marcil was both staunch agent and first reader; without Mark McIntire, the author and illustrator would never have found each other. Our thanks to them all.

The Anatomy of a House

THE ANATOMY OF A ROOF

The shape of the **roof** establishes the style of a house as well as sheltering the interior from weather. A **saltbox** suggests Colonial America, whereas a **mansard roof,** especially when topped off with a **cupola,** is typically Victorian. The steeper the pitch or angle of the roof, the more efficiently it will shed water and snow. Thus **flat** roofs are most suitable for dry climates. Houses which have been added to over time may have several intersecting roofs, sometimes in differing shapes.

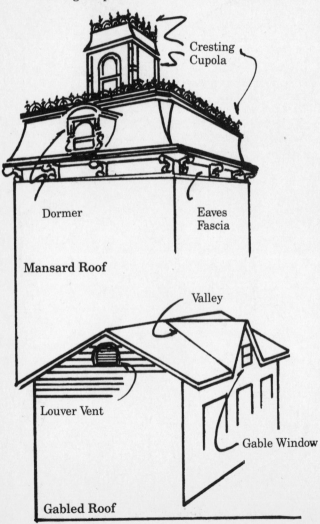

Cresting

Cupola

Dormer

Eaves
Fascia

Mansard Roof

Valley

Louver Vent

Gable Window

Gabled Roof

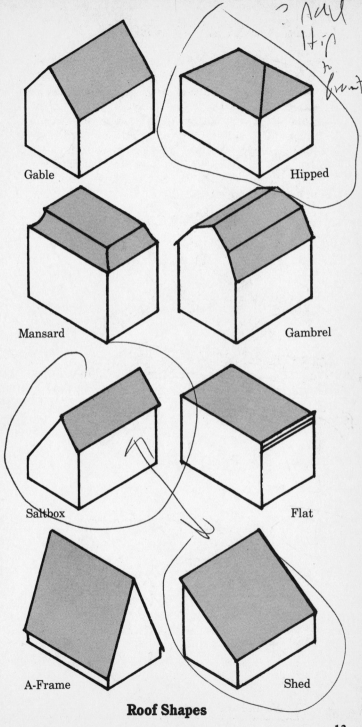

Gable

Hipped

Mansard

Gambrel

Saltbox

Flat

A-Frame

Shed

Roof Shapes

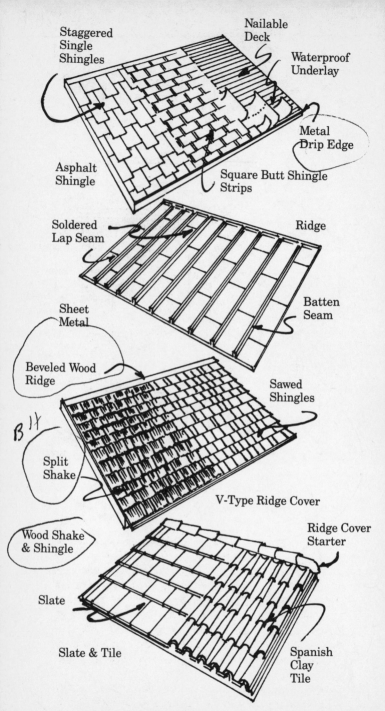

Roofing Material

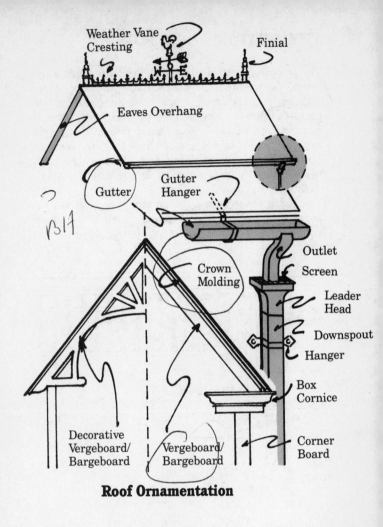

Roof Ornamentation

Roofing materials, whether **asphalt** or **wood shingles, tiles** or **sheet metal,** overlap like fish scales to shed water. Most roofs in this country consist of a wooden **deck** overlaid with sheets of **waterproof underlay,** on top of which the shingles, slates, or tiles are nailed in rows.

Most roofs are finished off at the **eaves** with **gutters:** metal or plastic pipes which collect water, channeling it via **downspouts** into the drainage system.

During the Victorian era, roofs were richly ornamented in iron or wood at the **crests** and **eaves;** simpler carvings enhanced country buildings.

THE ANATOMY OF A PORCH

The **porch,** for sitting or dining outdoors while sheltered from the weather, is one of the glories of American building. A porch is practical: **screens** may be hung to keep out bugs; **glass panels** trap sun and heat in cool weather. A porch is decorative: **posts** may be carved or turned, or may imitate classical **columns; balustrades** and **spandrels** range from restrained Colonial slats to exuberant Victorian curlicues.

A porch becomes a **portico** when supported by a **colonnade,** or row of columns. Such a structure adds formality and an element of rhythm to the exterior.

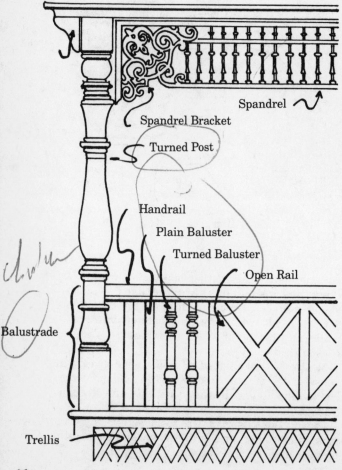

Spandrel

Spandrel Bracket

Turned Post

Handrail

Plain Baluster

Turned Baluster

Open Rail

Balustrade

Trellis

Porch Placement

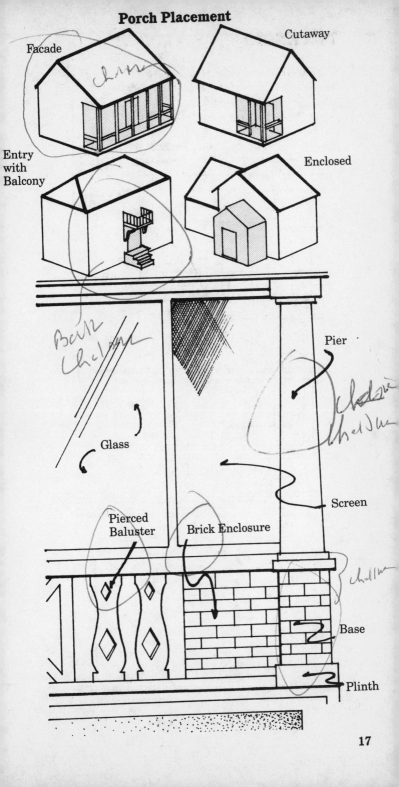

Facade

Cutaway

Entry
with
Balcony

Enclosed

Pier

Glass

Screen

Pierced
Baluster

Brick Enclosure

Base

Plinth

PORTICOS

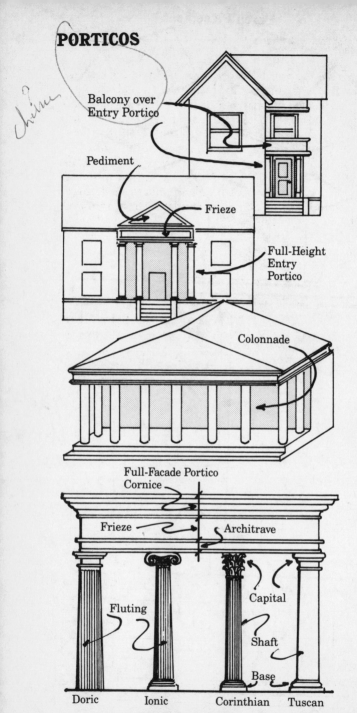

Balcony over Entry Portico

Pediment

Frieze

Full-Height Entry Portico

Colonnade

Full-Facade Portico

Cornice

Frieze

Architrave

Capital

Fluting

Shaft

Base

Doric Ionic Corinthian Tuscan

Column Styles

CHIMNEYS

A **chimney** encloses one or more **flues** (hollow passages) carrying smoke and heat to the outside from fireplace or furnace. Flues are lined with noncombustible material to protect the house from fire. The simplest chimney is an extension of a metal flue. More decorative chimneys may be built of brick or stone and may run either inside or outside the exterior wall of the house. Most chimneys are topped with a **cap** to disperse the smoke and to shed water. A **hood** may be added for protection from rain and wind.

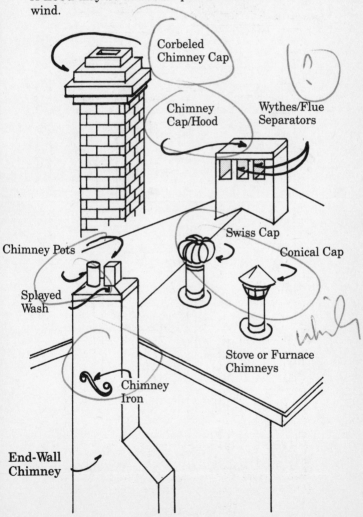

Corbeled Chimney Cap

Chimney Cap/Hood

Wythes/Flue Separators

Chimney Pots

Splayed Wash

Swiss Cap

Conical Cap

Stove or Furnace Chimneys

Chimney Iron

End-Wall Chimney

BOARD SIDING

The most traditional **siding** in many parts of America is **clapboard**—overlapping boards laid horizontally. Each board is either tapered or grooved, for a perfect fit and to keep moisture out.

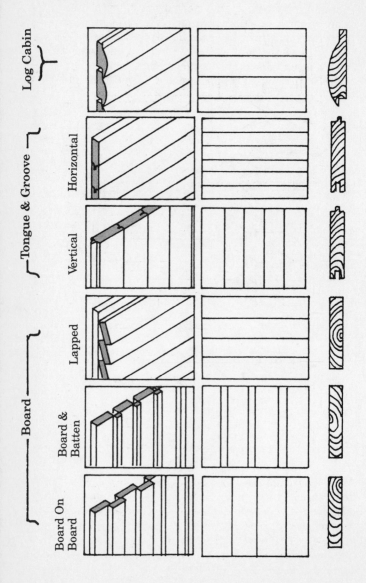

Log Cabin

Tongue & Groove
- Horizontal
- Vertical

Board
- Lapped
- Board & Batten
- Board On Board

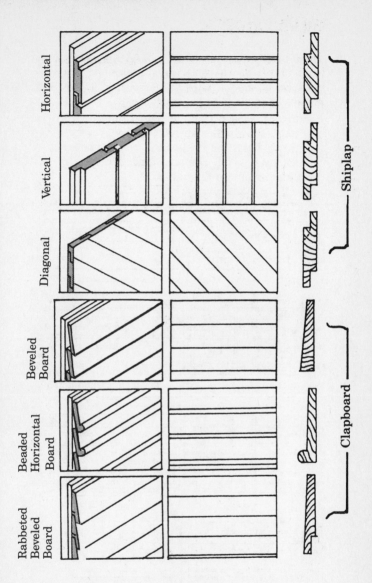

When board siding is laid vertically the joints are often covered with another strip of wood—generally narrower—for weatherproofing. This style is called **board and batten.** Although clapboard was originally made of wood and painted, low-maintenance versions in permanently colored metal or vinyl are popular today.

21

BRICKWORK

Many **brickwork** patterns are very ancient, having come to this country with the first settlers. In America the commonly used brick veneer, a single brick facing approximately four inches thick, is applied to a standard wooden frame in much the same way as clapboard or shingle. Mortar, a mix of cement, sand, and water, holds the bricks in place. Bricks vary tremendously in color, the most prized being the soft mottled rose of kiln-fired old ones.

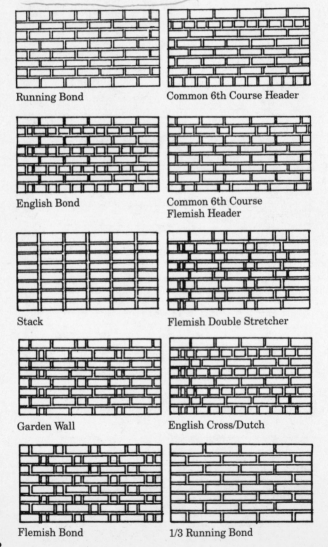

Running Bond

Common 6th Course Header

English Bond

Common 6th Course
Flemish Header

Stack

Flemish Double Stretcher

Garden Wall

English Cross/Dutch

Flemish Bond

1/3 Running Bond

STONEWORK

Stone, like brick, is more often used in this country as veneer than as a structural material. Some stone is used in its natural shape—this is often called **fieldstone.** Otherwise, the stone is cut into regular rectangles and fitted together in somewhat the same way as brick. Like bricks, stonework is held together by mortar.

In some parts of the country, **stucco,** a rough cementlike material, is used for exterior walls. Any flat wall may be accented with **quoins,** decorative stonework at the corners.

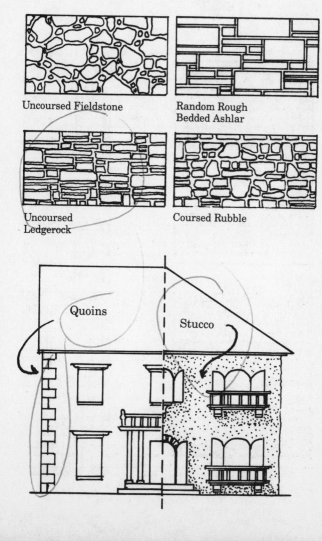

Uncoursed Fieldstone

Random Rough
Bedded Ashlar

Uncoursed
Ledgerock

Coursed Rubble

Quoins

Stucco

DRESSED STONE

The most formal building facing material is cut, or **dressed,** stone. Each stone may have **beveled edges** and may be **rusticated**—set to protrude conspicuously from the mortar. This style of stonework is often imitated in cast cement.

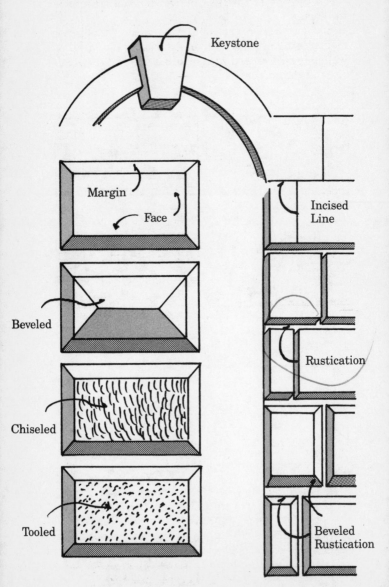

Keystone

Margin

Face

Incised Line

Beveled

Rustication

Chiseled

Tooled

Beveled Rustication

SHINGLES

Wooden **shingles** are laid in overlapping rows, whether on roofs or walls, to shed water. They may be split—separated naturally along the natural grain and commonly called shakes—or sawed.

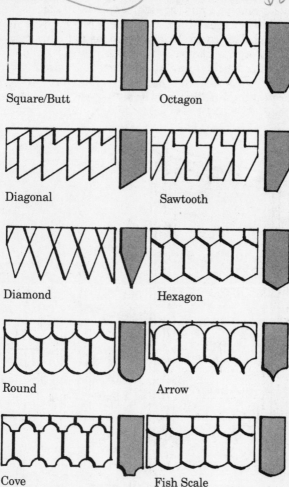

Square/Butt

Octagon

Diagonal

Sawtooth

Diamond

Hexagon

Round

Arrow

Cove

Fish Scale

Most shingles taper in thickness toward the top to give the finished wall a neat appearance. The visible ends may be shaped to produce a decorative surface pattern. Shingles cut from a stone called slate may be similarly shaped, a technique very popular in Victorian houses. Although shingles may be painted, cedar ones are usually left to weather naturally.

THE ANATOMY OF A DOOR

The front **entry door** of a house both welcomes the visitor and protects the inhabitants. It is usually the largest and most elaborate of the entries, harking back to ceremonial portals in ancient and medieval noble houses. From the eighteenth century on, as the middle classes came to dominate society, every householder could declare his home to be his castle by decorating the entry with **fanlights, transoms,** or **fluted pilasters.** All exterior doors are heavy; some may be reinforced with metal for further protection. For further door styles, see the chart on page 28.

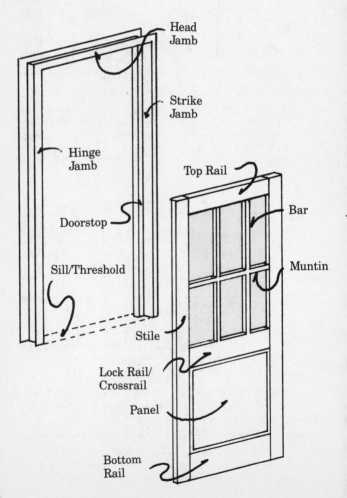

Head Jamb

Strike Jamb

Hinge Jamb

Top Rail

Bar

Doorstop

Muntin

Sill/Threshold

Stile

Lock Rail/ Crossrail

Panel

Bottom Rail

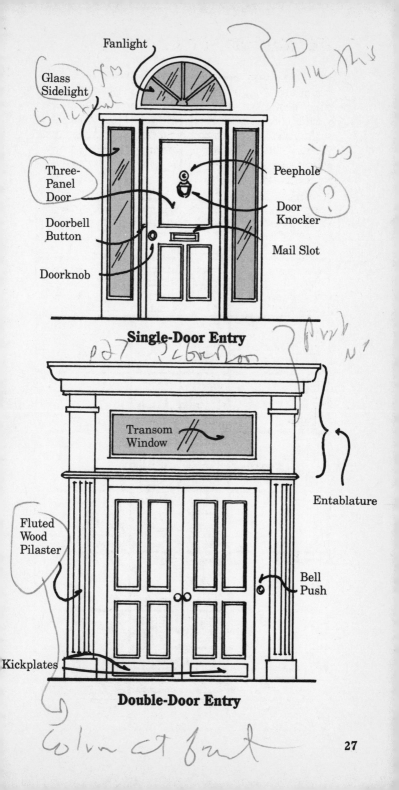

Fanlight

Glass Sidelight

Three-Panel Door

Doorbell Button

Doorknob

Peephole

Door Knocker

Mail Slot

Single-Door Entry

Transom Window

Entablature

Fluted Wood Pilaster

Bell Push

Kickplates

Double-Door Entry

DOOR CHART

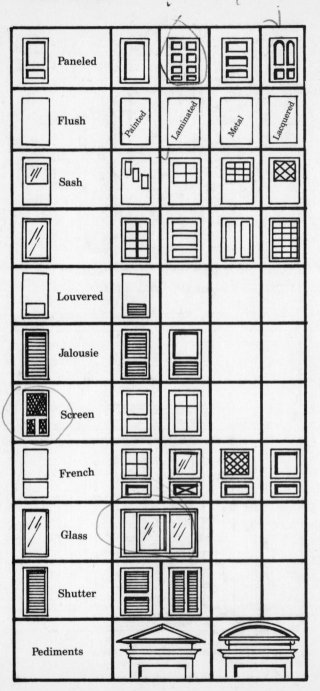

		Painted	Laminated	Metal	Lacquered
	Paneled				
	Flush				
	Sash				
	Louvered				
	Jalousie				
	Screen				
	French				
	Glass				
	Shutter				
	Pediments				

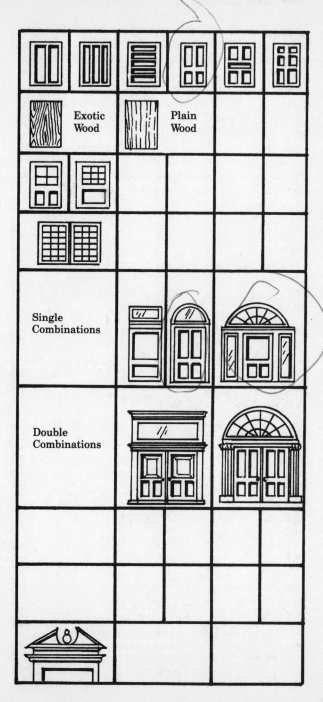

Exotic Wood

Plain Wood

Single Combinations

Double Combinations

THE ANATOMY OF A DOORKNOB

Entry-door hardware serves the double function of protection and decoration. The only strict necessities are an efficient **lock** and some sort of **handle,** but nearly infinite variations on this theme are to be found. Lock and handle may be separate or integrated in a single **escutcheon,** or metal plate. The handle may be a simple **knob** or an elaborate brass object complete with **thumb latch.** Perhaps regrettably, most people today feel the need of extra locks and security **bolts** of various designs. **Knockers, kickplates, peepholes, mail slots,** and devices to hold a door open or control the speed of its closing may be added as desired. For design variations, see the Door Hardware Chart on page 52.

Mortise Cylinder Lock

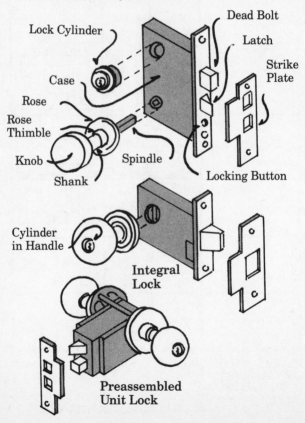

Lock Cylinder

Dead Bolt

Latch

Strike Plate

Case

Rose

Rose Thimble

Knob

Spindle

Shank

Locking Button

Cylinder in Handle

Integral Lock

Preassembled Unit Lock

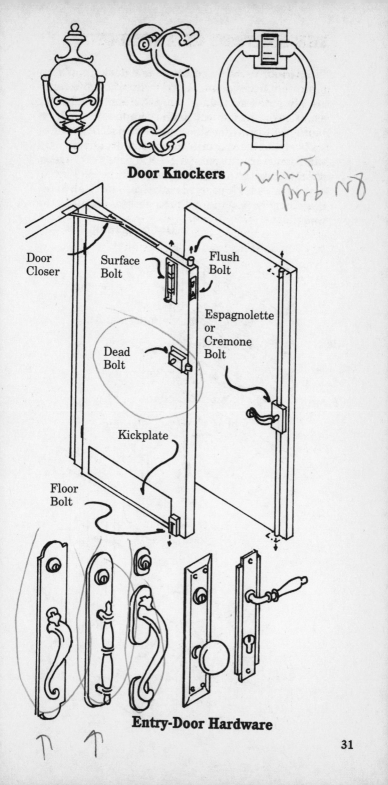

Door Knockers

Door Closer

Surface Bolt

Flush Bolt

Espagnolette or Cremone Bolt

Dead Bolt

Kickplate

Floor Bolt

Entry-Door Hardware

31

THE ANATOMY OF A WINDOW

Windows are recessed into the exterior walls for protection from moisture. They are often differentiated from the surrounding flat surfaces by trim: for example, a segmental **arch,** complete with **keystone** or a **plain** or **decorative lintel.** The **sill** or shelf at the bottom of the frame is usually slanted slightly toward the outside to shed water. **Shutters,** once needed for protection from weather and intruders, are today purely decorative. Metal **shutter dogs** may be used to hold the shutters against the wall.

Double-Hung Window

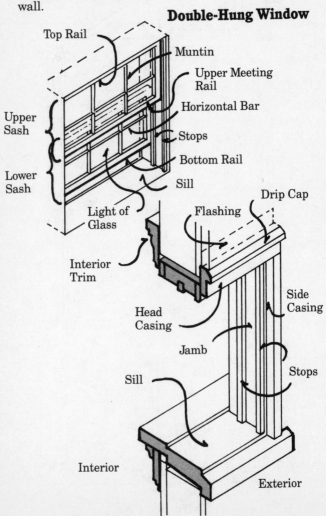

Top Rail

Muntin

Upper Meeting Rail

Horizontal Bar

Upper Sash

Stops

Bottom Rail

Lower Sash

Sill

Light of Glass

Drip Cap

Flashing

Interior Trim

Head Casing

Side Casing

Jamb

Stops

Sill

Interior

Exterior

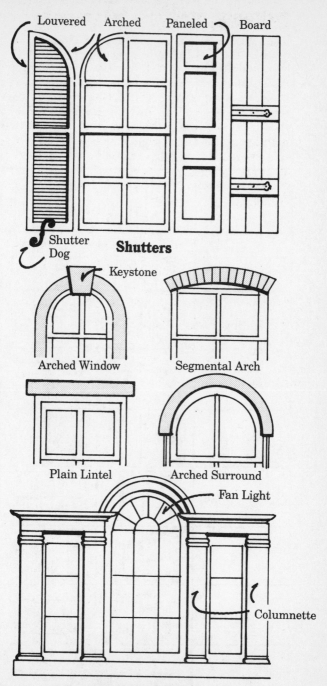

Louvered Arched Paneled Board

Shutter Dog **Shutters**

Keystone

Arched Window

Segmental Arch

Plain Lintel

Arched Surround

Fan Light

Columnette

Palladian Window

WINDOW CHART

		2/2	4/4	6/6
Double-Hung Sash				
Fixed				
Pivot		Transom		
Casement				
Sliding			Clear Story	
Awning			Clear Story	
Special				
Combinations				
			Fixed Double-Hung	
Protrusions	Bow		Bay	
Lintels	Plain		Decorative	

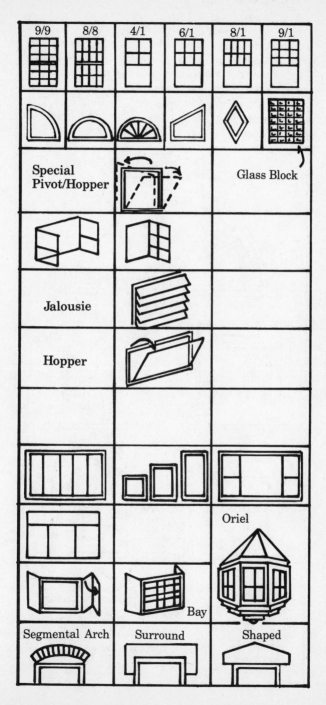

9/9	8/8	4/1	6/1	8/1	9/1

Special
Pivot/Hopper

Glass Block

Jalousie

Hopper

Oriel

Bay

Segmental Arch Surround Shaped

35

DORMERS

Various sorts of windows are cut into walls or roofs for illumination and/or ventilation. An **eyebrow window** below the eaves brightens a low-ceilinged upper room. For a lighter top floor, the roof may be pierced with **dormers,** projecting windowed structures usually echoing the shape of the main roof. The window is vertical rather than following the angle of the roof, thus avoiding possible leaks. Also see "The Anatomy of a Roof," page 12.

Dormer Shapes

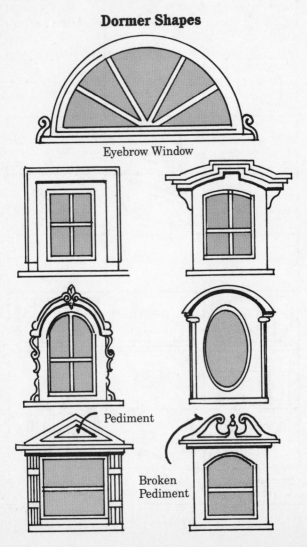

Eyebrow Window

Pediment

Broken
Pediment

SKYLIGHTS

A **skylight** illuminates a space from above. These windows are set directly into a flat or sloping roof, rather than within a subsidiary structure like a dormer. The variety of shapes available gives great design flexibility. The glass may open for ventilation but is usually fixed. Because skylights are notorious for their tendency to leak, it is important that they be very carefully installed, leaving no tiny gaps for water to enter. A skylight will inevitably allow some heat loss and should be placed in a sheltered position whenever possible. In areas with very intense sunlight, translucent glass may be preferable to clear; wire-embedded glazing will offer protection from unwanted visitors.

For more window shapes, see the chart on page 34.

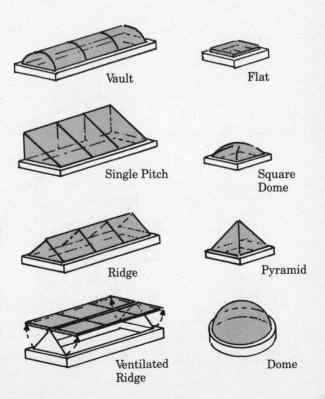

Vault

Flat

Single Pitch

Square Dome

Ridge

Pyramid

Ventilated Ridge

Dome

THE ANATOMY OF A CEILING

Simply defined, a **ceiling** is the top of the box which forms a room. It may be the underside of the floor of an upper story or of the roof. In general, ceilings are **dropped**—lowered to hide the structure above. However, to increase the height of a room, **beams** supporting the upper floors may be exposed or the space may be extended all the way to the roof for a **cathedral** or **shed** effect. Shaped ceilings such as **trays, vaults,** and **domes** also add to the spatial volume. Like all flat surfaces, ceilings are often embellished with **moldings** and painted decoration.

Ceiling Decorations

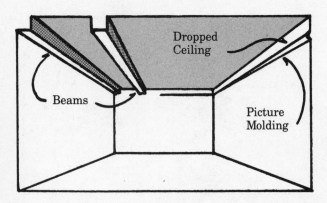

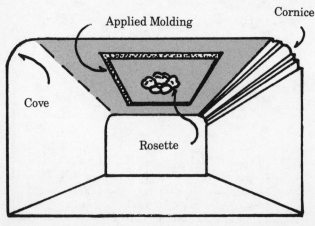

Ceiling Shapes

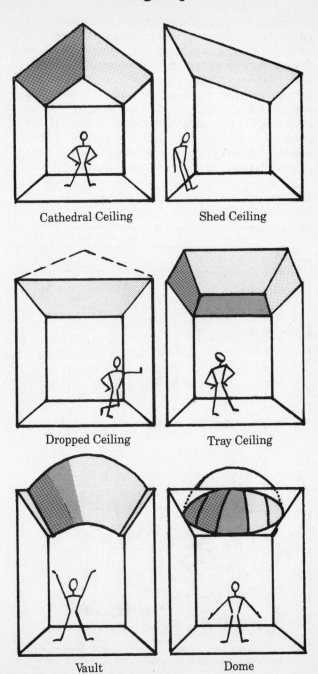

Cathedral Ceiling

Shed Ceiling

Dropped Ceiling

Tray Ceiling

Vault

Dome

THE ANATOMY OF A WALL

Although in very basic structures windows and doors are simply holes punched in the flat surface of the **wall,** the openings are usually articulated with more or less elaborate **moldings.** Wooden or metal door and window **casings** or **frames** protect walls from damage caused by opening and closing doors and windows. The ceiling may be offset by a **cornice molding,** the floor by a **baseboard,** and the wall divided by decorative elements like **chair rails** or **picture moldings** in various motifs. **Egg-and-dart** and **dentil** are two of the most popular molding motifs. **Paneling** may decorate the **dado** zone between chair rail and baseboard or may embellish the entire wall surface.

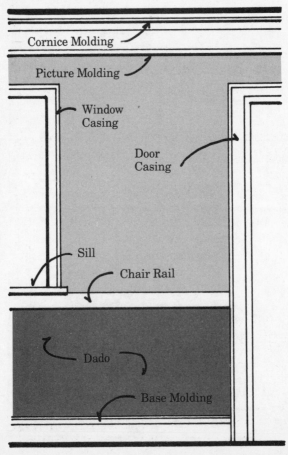

Cornice Molding

Picture Molding

Window Casing

Door Casing

Sill

Chair Rail

Dado

Base Molding

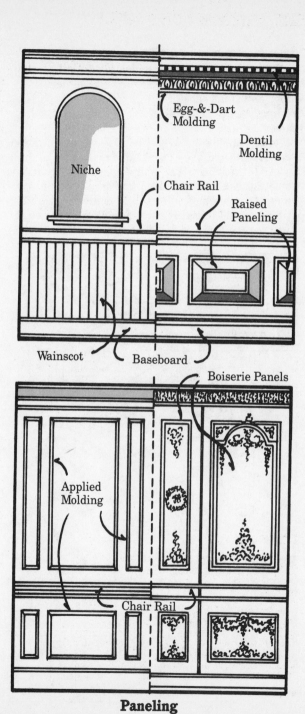

Egg-&-Dart Molding

Dentil Molding

Niche

Chair Rail

Raised Paneling

Wainscot

Baseboard

Boiserie Panels

Applied Molding

Chair Rail

Paneling

MOLDINGS

Moldings are decorative elements applied to the wall to vary the surface and/or to articulate openings, ceilings, and floors. Molding shapes derive from wood and stone carvings originally found in classical temples and medieval churches. Today, they are manufactured mostly in wood, plastic, or cement. Moldings may be combined, as in the ornate **cornice** and **baseboard** below, or used to make up a mantelpiece. In varying sizes, shapes, and combinations, moldings can be used to improve the visual proportions of a room as well as to add decorative interest. For more molding shapes and applications, see the chart on page 44.

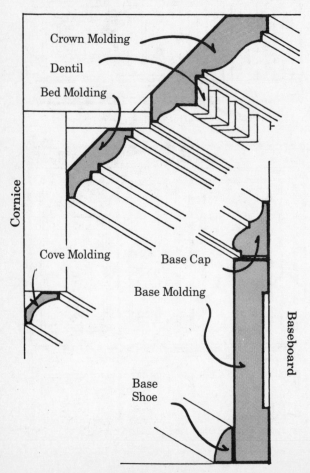

Crown Molding

Dentil

Bed Molding

Cornice

Cove Molding

Base Cap

Base Molding

Baseboard

Base Shoe

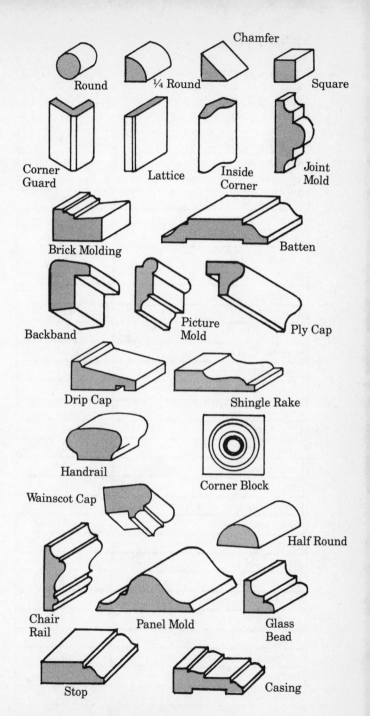

Round ¼ Round Chamfer Square

Corner Guard Lattice Inside Corner Joint Mold

Brick Molding Batten

Backband Picture Mold Ply Cap

Drip Cap Shingle Rake

Handrail Corner Block

Wainscot Cap Half Round

Chair Rail Panel Mold Glass Bead

Stop Casing

Molding Profiles

MOLDING CHART

Imaginatively used, **moldings** add design finesse easily and inexpensively. For instance, they may be combined to make up handsome **door** and **window frames** as well as **mantelpieces.**

MOLDING TYPE	No. of Styles
Backband	1
Base Cap	2
Base Molding	3
Base Shoe	2
Batten	1
Bed Molding	3
Brick Molding	1
Casing	3
Chair Rail	4
Chamfer	1
Corner Guard	2
Cove Molding	2
Crown Molding	3
Dentil	2
Drip Cap	1
Glass Bead	3
Half Round	1
Handrail	3
Inside Corner Molding	2
Joint Molding	1
Lattice	1
Panel Mold	1
Picture Mold	4
Ply Cap	2
Quarter Round	1
Round	1
Shingle Rake	2
Square	1
Stop	2
Wainscot Cap	4

Baseboard · Chair Rails · Doors · Windows · Ceiling Surface · Cornices · Mantelpieces · Paneling · Cabinetry · Pilasters · Staircases · Lighting · Picture Frames

THE ANATOMY OF DOORS AND FRAMES

Doors separating the areas within a house need not be as heavy as those on the exterior, since their function is to provide privacy rather than protection. The interior door **frame,** though less massive than the entry door frame, has all the same elements. Although normally **hinged** to swing in one direction only, doors may be hung to open in a variety of ways. When space is extremely scarce, doors may **slide** and **stack,** either behind each other or into **pockets**—specially constructed spaces inside the walls. **Bifold** doors, hinged to fold in either direction, leave a completely clear opening, while **swinging doors** allow access from either side.

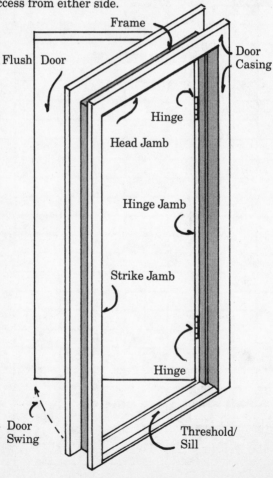

Frame

Flush Door

Door Casing

Hinge

Head Jamb

Hinge Jamb

Strike Jamb

Hinge

Door Swing

Threshold/ Sill

Interior Door Openings

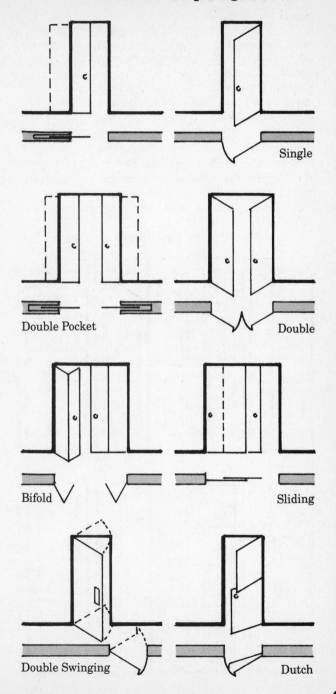

Single

Double Pocket

Double

Bifold

Sliding

Double Swinging

Dutch

47

PANELED DOORS

A **flush door** has a perfectly flat surface, but most doors are **paneled** to add decorative interest and reduce weight. Moldings are sometimes applied to flush doors to imitate paneling.

Doorframes may be simply **flat boards** or may have carved moldings, fluted **pilasters**, or even elaborate **pediments**, depending on the style of the building. When adding doors and doorframes, be sure they are compatible with the originals. For more doors, see the chart on page 28.

Paneled Doors

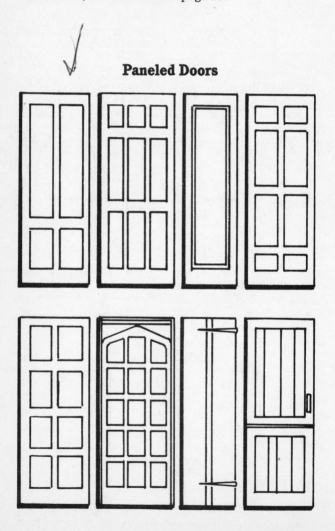

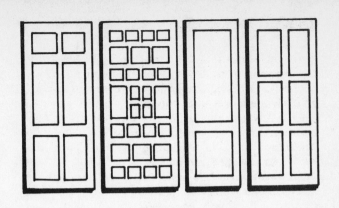

DECORATIVE DOOR FRAMES

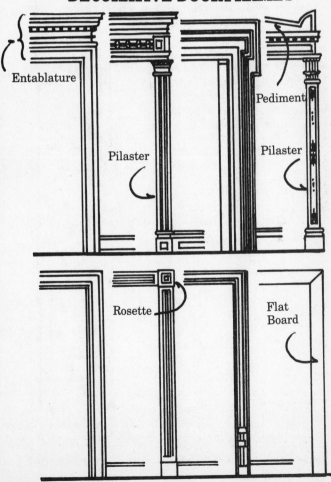

Entablature

Pilaster

Pediment

Pilaster

Rosette

Flat
Board

49

INTERIOR DOOR HARDWARE

Hardware for interior doors is a very important and often neglected element of house style. The hardware throughout a house or apartment should be consistent in style. Although round **knobs** are more common, **lever handles** may be preferable for elderly, handicapped, or delicate-handed people.

A great many hardware designs are available; the handsomest are not necessarily the most expensive. However, door handles get constant wear and should be made of solid metal. Privacy, in bathrooms for instance, can be assured by locking devices, either separately installed or integrated into the knob.

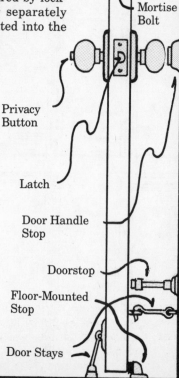

Thumb Turn

Mortise Bolt

Privacy Button

Latch

Door Handle Stop

Doorstop

Floor-Mounted Stop

Door Stays

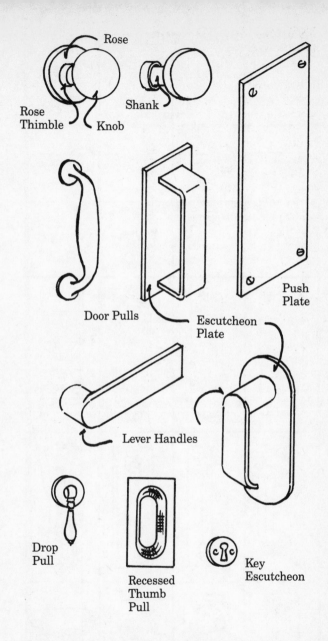

Rose

Shank

Rose
Thimble
Knob

Push
Plate

Door Pulls

Escutcheon
Plate

Lever Handles

Drop
Pull

Recessed
Thumb
Pull

Key
Escutcheon

Knobs with **latches** in the doorframe are necessary to keep doors shut; **pulls** without latches are sufficient when privacy is not needed. **Doorstops** prevent damage to door and wall; **push plates** keep fingerprints to a minimum. See the Door Hardware Chart on page 52.

DOOR HARDWARE CHART

Escutcheon Plates

Door Pulls

Escutcheons

THE ANATOMY OF WINDOW TRIM

Like a door, a **window** may be sunk into the wall without a **frame** or **casing**. Usually, however, windows are framed to define the shape and echo the style of the house. Like doorframes, of which they are normally miniatures, window frames may be quite plain or very elaborate. A complicated frame may be created economically by juxtaposing several different moldings. Windows set deeply into thick walls offer opportunities for the use of decorative molding and paneling.

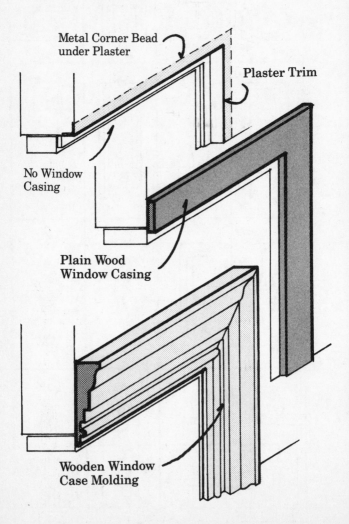

Metal Corner Bead under Plaster

Plaster Trim

No Window Casing

Plain Wood Window Casing

Wooden Window Case Molding

DECORATIVE WINDOW CASINGS/ FRAMES

Interior shutters are unusual today, but for centuries provided both insulation and, when closed with a heavy metal bar, burglar protection. Today they are used as an alternative to curtains or blinds.

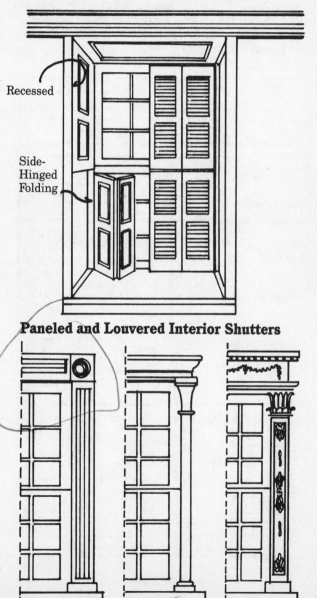

Recessed

Side-
Hinged
Folding

Paneled and Louvered Interior Shutters

I Like this

WOOD FLOORS

Wood, one of the warmest and most resilient of materials, is the most popular flooring in this country. **Planks** in either hard (for example, oak) or soft (such as pine) wood may be of uniform or random width; sometimes, as in early American houses, they are attached to the underfloor structure by wooden pegs. **Parquet** floors are intricately patterned in one or more kinds and colors of wood and, conveniently, are also available in ready-to-install tiles.

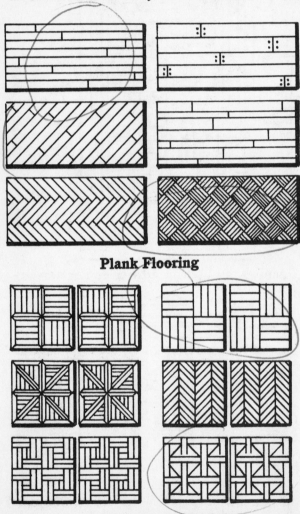

Plank Flooring

Parquet Flooring

TILE FLOORS

Tile floors are prized in hot climates for their cool surface. Terra cotta (cooked earth) is a common natural color, but plain and decorated tiles come in an infinity of hues and shapes. They are laid in a variety of patterns ranging from simple to highly decorative. Tiles are laid in grout, a viscous mortar of matching or contrasting color which holds them in place and defines the patterns. Tiles must be sealed to prevent staining; finishes are either shiny or matte.

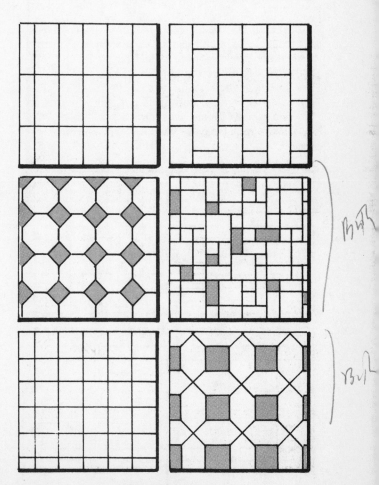

Tile Patterns

HARD FLOORINGS

All **hard floorings**—tile, brick, and stone—are appropriate for areas with very high traffic because, properly laid and finished, they show little wear and are easy to clean. They are equally suitable for indoor and outdoor use, although in cold climates outdoor floorings must be installed on a base of sand and gravel which expands and contracts with temperature changes. To further prevent frost damage, the pieces are not grouted together; instead, sand is brushed across the surface until all gaps are filled.

BRICK FLOORS

Brick is laid in a nearly infinite variety of patterns, each of which has its own history and decorative value. Brick floors are ideal for paths and hallways, but are not recommended for kitchens because the rough surface is more difficult to clean than other hard surfaces, and brick is tiring to stand on for long periods. In old houses with brick floors, rugs or wooden mats may be used underfoot in work areas.

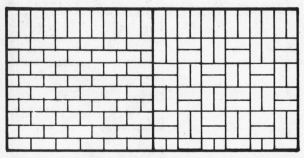

Brick Patterns

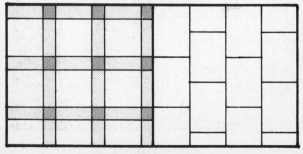

Stone Patterns

STONE FLOORS

Marble, either in slabs or, more usually, in pre-cut shapes laid like tiles, is the most common stone for floors. The pattern and color of the stone itself provides the characteristic beauty of marble floors. Two or more colors, laid in a checkerboard or other pattern, are often found in the same floor. **Aggregates** such as **terrazzo** use stone pieces in a solid matrix to form new patterns.

Common Stone Cuts

Marble Floor Patterns

Terrazzo Stone Aggregate

Reconstituted Stone Flooring

THE ANATOMY OF A STAIRCASE

Stairways connecting the levels of a house make one of the strongest statements of any design element. **Newel posts, balusters** and **banisters** establish style; the placement of **landings** sets a leisurely or rapid rhythm to the ascent. The ratio of **riser** height to width of **tread** makes the staircase more or less easy to climb; **spirals** are the hardest to climb but may be the only choice when space is tight. The **stringer** is the board which supports the ends of the steps.

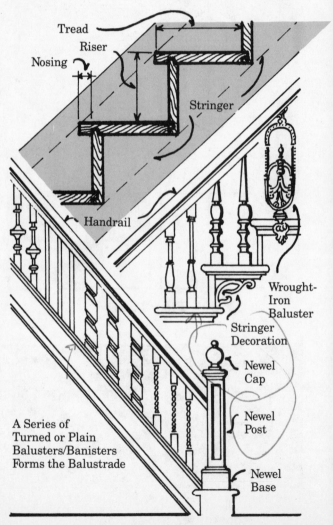

Tread

Riser

Nosing

Stringer

Handrail

Wrought-
Iron
Baluster

Stringer
Decoration

Newel
Cap

Newel
Post

A Series of
Turned or Plain
Balusters/Banisters
Forms the Balustrade

Newel
Base

STAIRWAYS

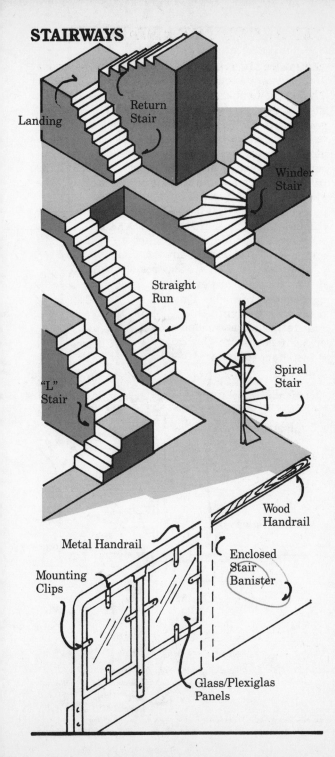

Landing

Return Stair

Winder Stair

Straight Run

"L" Stair

Spiral Stair

Wood Handrail

Metal Handrail

Enclosed Stair Banister

Mounting Clips

Glass/Plexiglas Panels

THE ANATOMY OF A FIREPLACE

An open log fire is a symbol of home in this country, despite the fact that it is the least efficient of heating devices. Modern versions of the **Franklin stove** are far more practical. With the doors closed the metal stove radiates heat; open, it is a small fireplace. **Glass-doored** models combine efficiency with visual pleasure. A variety of **inserts** are available to make an open fireplace into a useful heater by capturing and recirculating the heat before it rises up the chimney. Closing the **damper** blocks off the **flue** when the fireplace is not in use, minimizing heat loss. A fireplace may be formally centered on a wall, tucked cozily in a corner, or even opened on two sides for double enjoyment. The **mantelpiece**, a wooden or stone surround, adds decorative style.

Flue

Smoke Chamber

Mantelshelf

Mantelpiece

Damper

Damper Handle

Lintel

Fireplace

Hearthstone

Ash Dump

Air Intake

Clean-out Door

Ash Pit

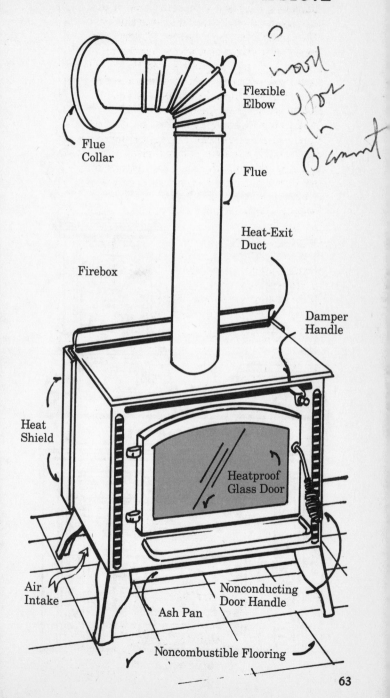

THE ANATOMY OF A STOVE

Flue
Collar

Flexible
Elbow

Flue

Heat-Exit
Duct

Firebox

Damper
Handle

Heat
Shield

Heatproof
Glass Door

Air
Intake

Nonconducting
Door Handle

Ash Pan

Noncombustible Flooring

63

Decorative Stoves

Fireplace Insert

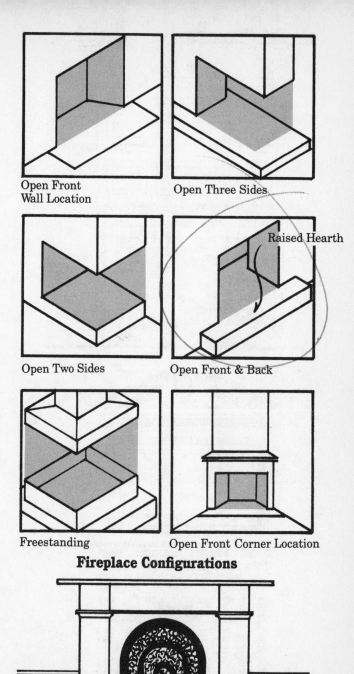

Open Front
Wall Location

Open Three Sides

Open Two Sides

Raised Hearth

Open Front & Back

Freestanding

Open Front Corner Location

Fireplace Configurations

Victorian Cast-Iron Fireplace Insert

65

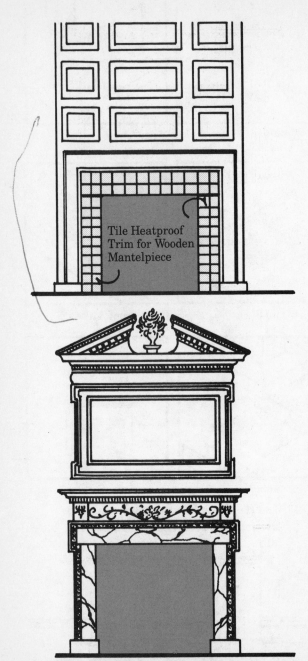

Tile Heatproof Trim for Wooden Mantelpiece

Fireplaces with Overmantels

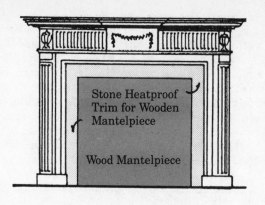

Stone Heatproof
Trim for Wooden
Mantelpiece

Wood Mantelpiece

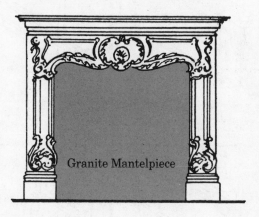

Granite Mantelpiece

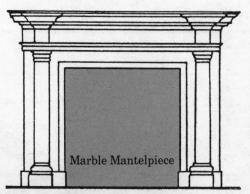

Marble Mantelpiece

Traditional Mantelpieces

RADIATORS AND THEIR COVERS

Heat is usually transmitted to the rooms of a house by **radiators**. Different fuels (oil, gas, electricity) are used, depending on the type of furnace. The steam and hot water produced by any fuel circulate through metal pipes, giving off radiant heat. Metal **fins** increase radiation. Hot air heat is generally delivered from **vents** in the lower wall or floor. Because heat rises, radiators of all sizes are placed as low on the wall as possible, generally in front of windows to combat drafts and heat loss through the glass.

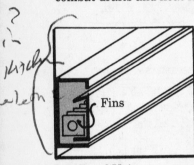

Baseboard Unit

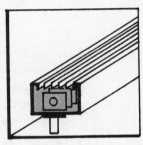

Freestanding Unit

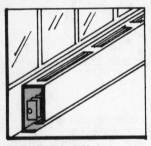

Wall-Mounted Unit

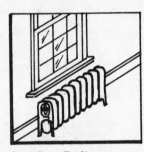

Cast-Iron Radiator

Recessed Wall Heater

Flush Floor Register

In houses with no basement, slab floors should be laid on gravel to provide a bit of insulation. In a cold climate, low-voltage **electric coils** may be laid on top of the gravel. Their purpose is to create a cold barrier at floor level rather than to heat the air.

Radiator covers in metal or wood are a neat finishing touch. The solid top pushes heat forward through a **grille**, making the radiator more efficient. Painted to match or contrast with the walls, a radiator cover can be either inconspicuous or part of the design statement.

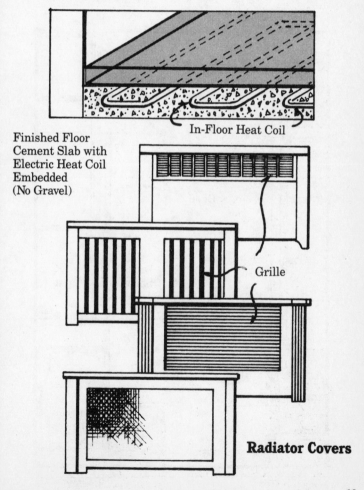

In-Floor Heat Coil

Finished Floor
Cement Slab with
Electric Heat Coil
Embedded
(No Gravel)

Grille

Radiator Covers

STORAGE

Built-in units not only provide storage suited to your particular needs, they also hide architectural irregularities. Beams, pipes, and rough plaster disappear behind bookshelves and cupboards. In a small room a **drop shelf** makes a handy desk without using scarce floor space. A **pull-out television shelf** may slide and swivel, yet disappear when not in use. Bookshelves carried over a doorway, possibly on both sides of the wall, give architectural interest to an otherwise ordinary passage door. Handsome hardware and elegant moldings bring the finished look of fine paneling to well-designed built-in storage. **Lighting** may be added to highlight favorite objects or collections.

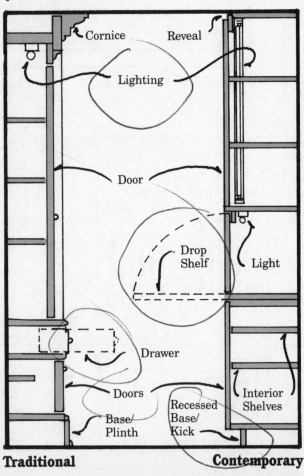

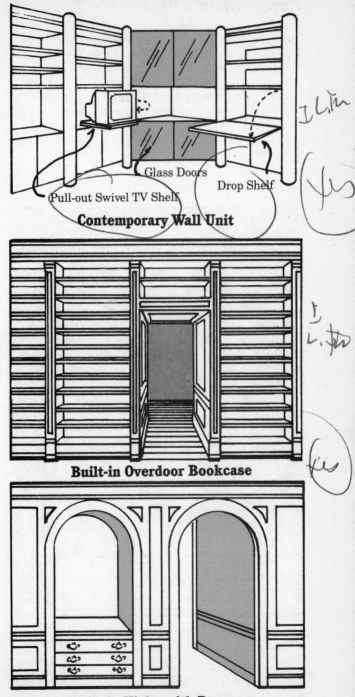

Contemporary Wall Unit

Glass Doors

Pull-out Swivel TV Shelf

Drop Shelf

Built-in Overdoor Bookcase

Built-in Niche with Drawers

71

THE ANATOMY OF A CLOSET

Well-organized **closets** are an achievable luxury. Start by figuring out how much space you need for each category of clothing: long dresses and robes require *five feet* of hanging height; street-length dresses and trousers need *four feet;* suits, blouses, and skirts, about *thirty-nine inches.* **Drawers** or **shelves,** either fixed or sliding, hold shirts, sweaters, and underwear. Shoes are stored at floor level or on angled shelves with a rod across for the heels.

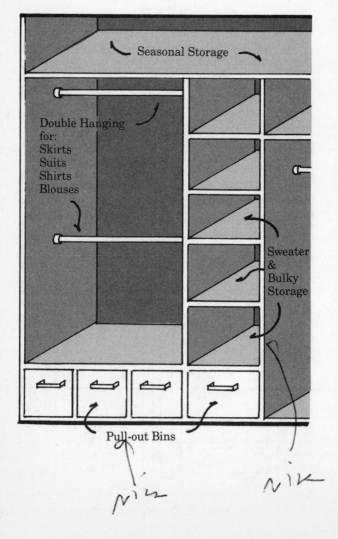

Seasonal Storage

Double Hanging for:
Skirts
Suits
Shirts
Blouses

Sweater & Bulky Storage

Pull-out Bins

Handbags are easy to find if stored upright; hooks or pegs keep belts and ties in order. A shelf across the top of the closet keeps hats and seldom-worn clothes out of the way but accessible. Felt-lined shallow drawers are excellent for jewelry storage. A **mirror** is a necessity, as is good lighting.

Closets lined in cedar wood discourage moths; they are especially useful for storing winter clothes during the summer. In a bedroom, built-in closets may be concealed behind paneled doors; in a dressing room doors are unnecessary.

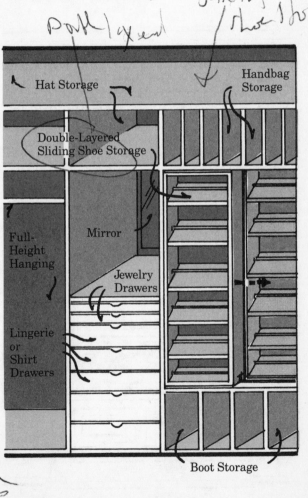

Hat Storage

Handbag Storage

Double-Layered Sliding Shoe Storage

Full-Height Hanging

Mirror

Jewelry Drawers

Lingerie or Shirt Drawers

Boot Storage

BUILT-IN SEATING

Window seats and **banquettes** (built-in benches) add both seating and storage in a minimum of space. A window seat is the ideal spot for reading or just enjoying the view. Banquettes allow comfortable dining in spaces too small for a full set of chairs. All these seats may be hinged for access to storage for firewood, games, or linens. **Cushions** hide the hinges and make the seat cozy.

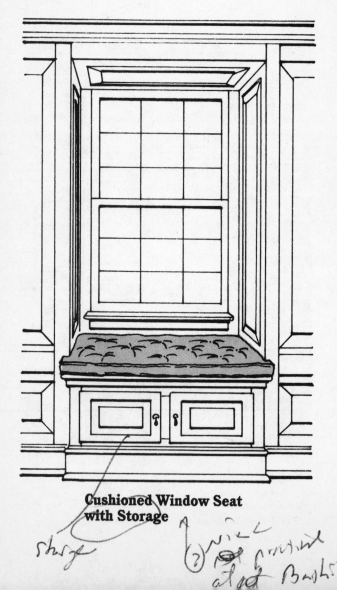

Cushioned Window Seat with Storage

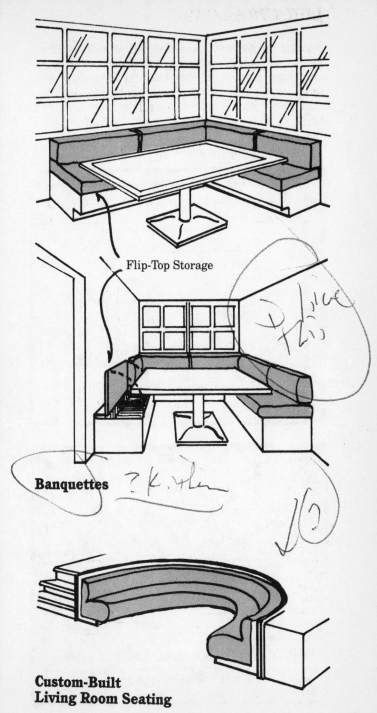

Flip-Top Storage

Banquettes

**Custom-Built
Living Room Seating**

LIGHTING

The type, placement, and intensity of **lighting** has an enormous impact on the overall design. Unfortunately, it is also the hardest part of the design plan to understand. The first consideration must be function—what kind of light is needed to accomplish the task?

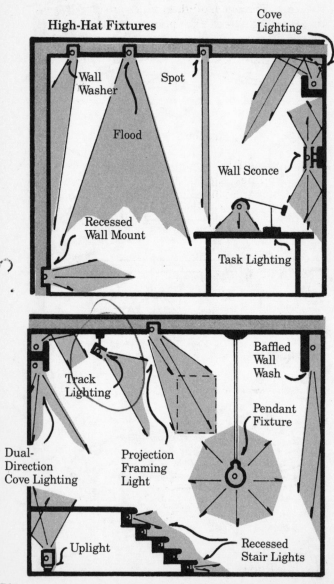

High-Hat Fixtures

Cove Lighting

Wall Washer

Spot

Flood

Wall Sconce

Recessed Wall Mount

Task Lighting

Baffled Wall Wash

Track Lighting

Pendant Fixture

Dual-Direction Cove Lighting

Projection Framing Light

Uplight

Recessed Stair Lights

A bright **task light** (for example, a desk lamp) is best for reading; a soft **wash** is needed to banish shadows from the ceiling. Pictures may be lit by a **projection framing light** on the ceiling or by a fixture on the frame; stairs are made safer by lights recessed beneath the treads. A row of **sconces** brightens a hall while a **pendant** (a chandelier for instance) may be dimmed to complement candlelight in the dining room. **Uplights,** which are usually concealed behind furniture or plants, dramatically illuminate a corner from below or subtly establish a mood. See the lighting chart on page 000.

FANS

Ceiling-hung fans maximize the efficiency of both cooling and heating. Fans are designed in many styles, from streamlined to the traditional tropical. Lights are often added to make them even more versatile.

Flush-Mounted Fan

Extended-Mount Fan
with Light

LIGHTING CHART

Each kind of **fixture** or **receptacle** gives a different shape of light, while each bulb (or **lamp**) emits a different intensity and color. You can choose a light designed for every need, whether that of reading, illuminating a picture, or directing traffic along a hall or path. A large project may be sufficiently complex to justify calling in a lighting designer to analyze the problems and provide solutions. Otherwise, trial and error will eventually produce a satisfactory lighting arrangement, usually involving a combination of light sources and colors.

RECEPTACLE STYLES	
	Recessed in Ceiling
	Surface-Mounted on Ceiling
	Pendant/Chandelier
	Track
	Built-in/Cove
	Wall-Mounted/Sconce
	Freestanding/Task
	Uplighting
	Specialty/Step Lighting
	Outdoor

LAMP STYLES

Incandescent	Fluorescent	Halogen	Low voltage	Cold cathode
Incandescent—produces light when electric current heats a tungsten filament to glowing. Comes in many different colors, easy on the eye but heat-producing.	**Fluorescent**—produces light when electricity flows through mercury vapor in a sealed glass tube, causing a phosphor coating on the inner surface to glow. Little heat is produced. Modern bulbs are often color-corrected for warmth.	**Halogen**—a variation of the incandescent bulb, wherein halogen gas reacts with the tungsten filament to produce intense light and much heat. Halogen bulbs are small but have a long life.	**Low voltage**—transformers are used to lower voltage in household current, producing less light but a longer bulb life. Generally used in hard-to-reach places for a soft general glow.	**Cold cathode**—a relative of fluorescent and neon lighting. Thin, bendable tubes are available in many lengths and colors. Low heat emission makes this lighting suitable for permanent installations such as **cove lighting.**

�				

KITCHEN PLANS

A triangle formed by imaginary lines drawn from sink to stove to refrigerator defines kitchen work space. However the elements are arranged—and a great deal of flexibility is possible—motion along these lines must not be obstructed if the kitchen is to work smoothly. For maximum efficiency, the work area should not be so large as to require long walks; a second triangle connecting additional equipment is preferable if more than one cook is likely to use the space at the same time.

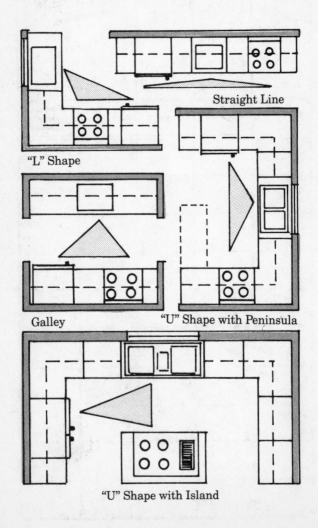

Straight Line

"L" Shape

Galley

"U" Shape with Peninsula

"U" Shape with Island

THE KITCHEN SINK

Sinks come in many shapes: single, double, or multiple. They may be shallow or deep; some are fitted with plastic-covered wire **baskets** or wood **chopping boards.** They may be made of steel, porcelain or plastic. Choose for both looks and function.

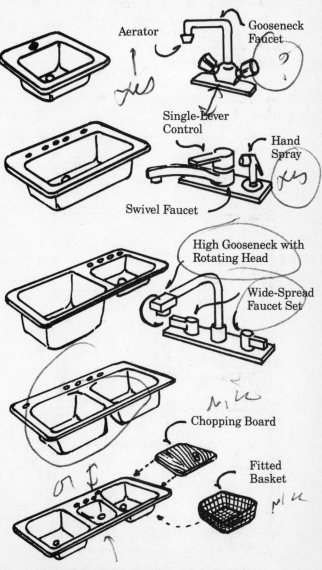

Aerator

Gooseneck Faucet

Single-Lever Control

Hand Spray

Swivel Faucet

High Gooseneck with Rotating Head

Wide-Spread Faucet Set

Chopping Board

Fitted Basket

Sink and Faucet Configurations

THE ANATOMY OF KITCHEN CABINETS

The **kitchen** is likely to be the most consistently designed room in the house. Occasionally, pieces of furniture are adapted to hold appliances and equipment, but the vast majority of kitchens are designed with rows of **built-in cabinets.** Literally hundreds of cabinet styles are available ready-made from lumberyards, furnishing stores, and showrooms. They are made of materials from metal to plastic to paneled wood with glass door fronts. Cabinets are fitted inside to hold everything from herbs to wineglasses to stockpots. If what you want is not available, kitchens may be custom-designed.

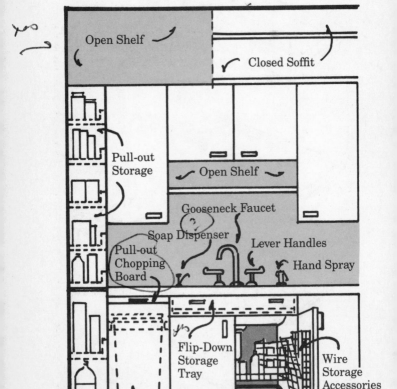

Open Shelf

Closed Soffit

Pull-out Storage

Open Shelf

Gooseneck Faucet

Soap Dispenser

Lever Handles

Pull-out Chopping Board

Hand Spray

Flip-Down Storage Tray

Wire Storage Accessories

Pull-out Tray

Pull-out Garbage Bin

Whether designing your own kitchen or working with a professional, be very specific about your work habits and kitchen possessions. A beautiful kitchen which does not work for you is worse than an old-fashioned but practical one. First place the sink and appliances, testing variations of the work triangle to find the most comfortable. Only then can the cabinets be laid out.

The outside design of the cabinets is important for the look of the kitchen; myriad interior options like sliding racks and pull-out shelves can be chosen to suit your needs. Choose the most comfortable counter height and the most practical countertop material; illuminate both the room and your work spaces. Making correct choices in the design stage pays off for the life of the kitchen.

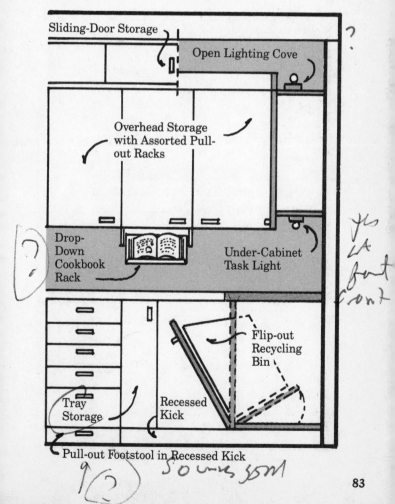

Sliding-Door Storage

Open Lighting Cove

Overhead Storage with Assorted Pull-out Racks

Drop-Down Cookbook Rack

Under-Cabinet Task Light

Flip-out Recycling Bin

Tray Storage

Recessed Kick

Pull-out Footstool in Recessed Kick

83

BATHROOM PLANS

The layout of a **bathroom** is completely dependent on the location of plumbing lines, which limits flexibility in existing structures. Convenience and privacy are goals to be achieved, and virtually all bathrooms need storage space. Creativity can be expressed in the choice of fixtures and counter materials as well as cabinetry and lighting. Many decorative styles are available in **sinks, tubs, shower stalls, bidets,** and **toilets** from reproduction Victorian to streamlined Italian modern. A well-planned bathroom, even with simple equipment, is a luxurious private retreat from the stresses of the outside world.

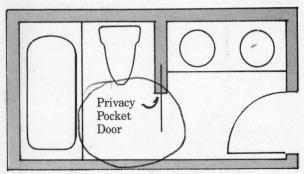

Privacy Pocket Door

Single-Entry Two-Part Bathroom

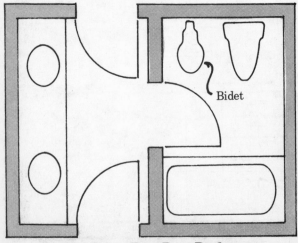

Bidet

Double-Entry Two-Part Bathroom

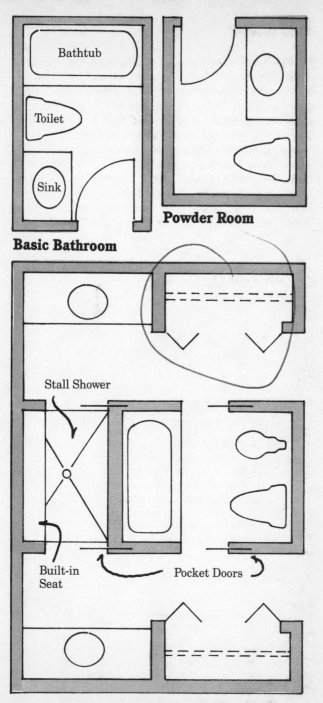

Basic Bathroom

Bathtub

Toilet

Sink

Powder Room

Stall Shower

Built-in Seat

Pocket Doors

His-and-Hers Bathroom

BATHTUBS

The **tub** is the largest, potentially most luxurious of bathroom fixtures. Tubs in enameled cast iron or lighter, less expensive but less stable acrylic may be fitted with **whirlpool jets.** To accommodate the weight of water in a very large tub, the bathroom floor may need reinforcement. A nonskid finish is normally applied to the bottom of the tub for safety and, if you should slip, a **grab bar** can prevent injury. A waterproof **recessed exhaust fan** removes steam quickly.

Deck-Mounted Whirlpool Bath

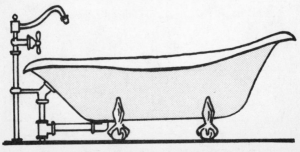

Classic Footed Tub

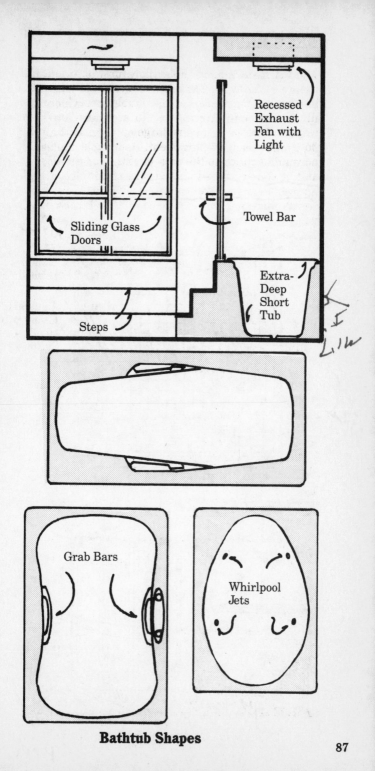

Recessed Exhaust Fan with Light

Sliding Glass Doors

Towel Bar

Extra-Deep Short Tub

Steps

Grab Bars

Whirlpool Jets

Bathtub Shapes

87

SHOWERS

Many designs are available to gratify the American taste for **showers**. The most common and least expensive is the shower within a bathtub, which requires a **shower curtain** or **sliding glass doors** to prevent floods, a nonslip floor, and a **grab bar** to stop falls. Separate **shower stalls** in molded plastic or mosaic tile usually have glass or plastic doors. Large **shower heads** maximize the invigorating spray; steam showers and saunas are further refinements for home spas. A **heated towel rack** is a practical luxury.

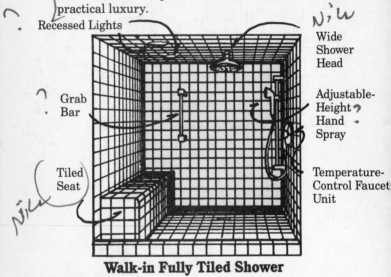

Recessed Lights

Wide Shower Head

Grab Bar

Adjustable-Height Hand Spray

Tiled Seat

Temperature-Control Faucet Unit

Walk-in Fully Tiled Shower

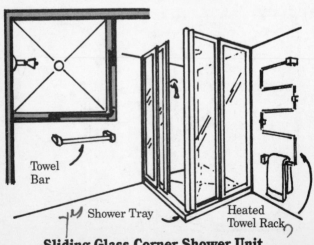

Towel Bar

Shower Tray

Heated Towel Rack

Sliding Glass Corner Shower Unit

88

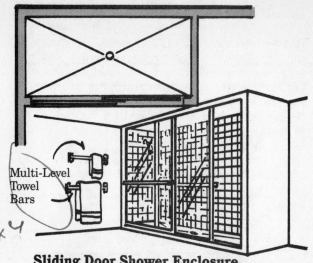

Multi-Level
Towel
Bars

Sliding Door Shower Enclosure

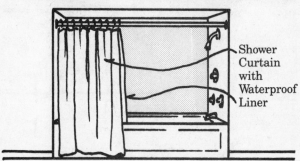

Shower
Curtain
with
Waterproof
Liner

Shower in Bathtub Niche

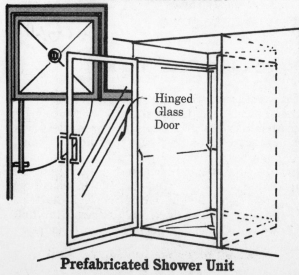

Hinged
Glass
Door

Prefabricated Shower Unit

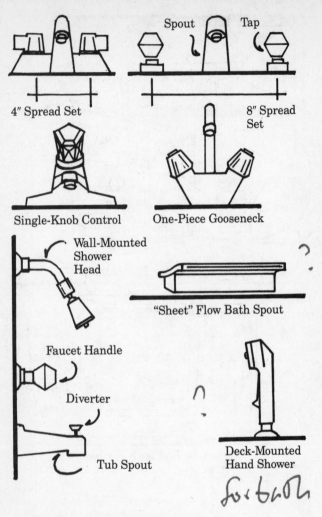

4″ Spread Set

Spout Tap

8″ Spread Set

Single-Knob Control

One-Piece Gooseneck

Wall-Mounted Shower Head

"Sheet" Flow Bath Spout

Faucet Handle

Diverter

Tub Spout

Deck-Mounted Hand Shower

BATHROOM HARDWARE

Like bathroom fixtures, **bathroom hardware** comes in many styles. Most sinks are predrilled to accommodate either a **one-piece** or **wide-spread faucet** set of hot and cold **taps** and **spout**. Tap handles may be traditional or ultramodern in design, using a variety of materials from brass and porcelain to marble and acrylic. Tub hardware is generally a larger version of the sink set. Showers may have separate controls or work off the tub set; **hand-held showers** are useful for rinsing hair and cleaning the tub.

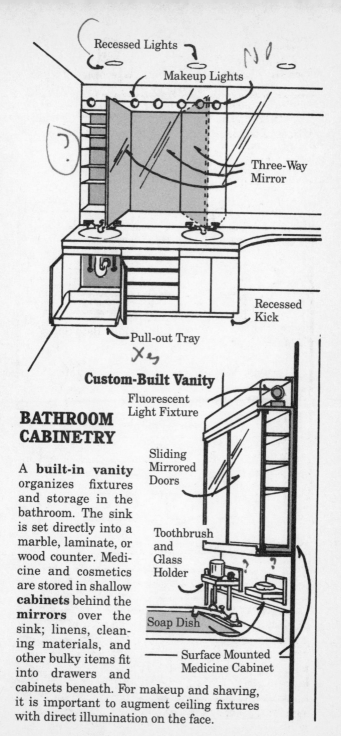

Recessed Lights

Makeup Lights

Three-Way
Mirror

Recessed
Kick

Pull-out Tray

Custom-Built Vanity

Fluorescent
Light Fixture

BATHROOM
CABINETRY

Sliding
Mirrored
Doors

A **built-in vanity**
organizes fixtures
and storage in the
bathroom. The sink
is set directly into a
marble, laminate, or
wood counter. Medi-
cine and cosmetics
are stored in shallow
cabinets behind the
mirrors over the
sink; linens, clean-
ing materials, and
other bulky items fit
into drawers and
cabinets beneath. For makeup and shaving,
it is important to augment ceiling fixtures
with direct illumination on the face.

Toothbrush
and
Glass
Holder

Soap Dish

Surface Mounted
Medicine Cabinet

TOILETS

Toilets and matching bidets, like other fixtures, come in many styles. Height is often a consideration—the most modern ones are low to the ground. The **tank** may be low, standard height, or raised like the old-fashioned **cistern**, which compensates for low water pressure.

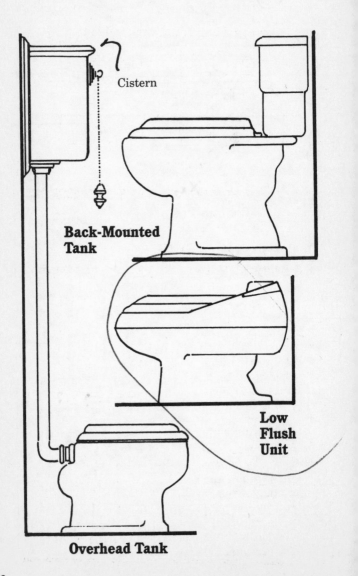

Cistern

Back-Mounted Tank

Low Flush Unit

Overhead Tank

BATHROOM SINKS

A bathroom **basin** may be **wall-mounted** or free-standing on a **pedestal**. In a vanity installation, the inset sink rim either rests on the counter or is attached under the edge of a hole cut to fit. Sinks in stone or synthetic solid-core materials are molded in **one piece** with the counter.

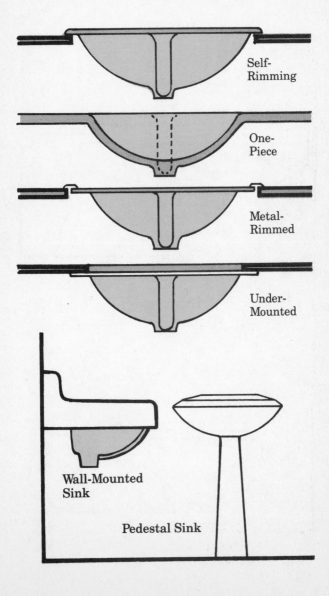

Self-
Rimming

One-
Piece

Metal-
Rimmed

Under-
Mounted

Wall-Mounted
Sink

Pedestal Sink

Directory

HAVING given a lot of thought to transforming your existing house into the dwelling of your dreams, you may find that your local lumberyard has never heard of the particular molding, doorknob, or window shape on which your heart is set. Do not despair!

Everything you need to renovate a house stylistically is available by mail order. This list includes many of the best and most widely distributed suppliers, but is by no means complete. Not only are literally hundreds of companies making fine products for interiors, but the field is rapidly growing. Magazines devoted to interior restoration, preservation, and style are rich sources of craftspeople and manufacturers.

All of the companies listed produce catalogs which they distribute either free or at moderate cost. The catalogs themselves are often full of good ideas for restoration projects.

If an architectural salvage yard exists near you, visit it often for inspiration. Perhaps the perfect door or column is there waiting for you. At the very least, you will see examples of different styles in their original forms.

Aged Woods

FIRST CAPITAL WOOD PRODUCTS, INC.
147 West Philadelphia St.
York, PA 17403
(800) 233-9307
In PA (717) 843-8104

A collection of authentic, antique, and rare woods for floors, walls, and ceilings. Boards, either distressed as they came from old buildings or milled from old wood. White and yellow pine, oak, American chestnut, cypress, and other woods stocked. Fieldstone, roofing slate, old beams, and barn siding also stocked. They will send samples with a refundable deposit. Free color brochure. **Roofs, wood siding, ceilings, walls, wood floors.**

ALLMILMO CORPORATION
70 Clinton Road
P.O. Box 629
Fairfield, NJ 07006
(201) 227-2502

Allmilmo makes kitchens and bathrooms in contemporary designs that are functionally innovative and comfortable.

They offer many different designs of their own, and can redesign your kitchen. Countertops are available in a variety of colors and surfaces, including granite and several kinds of wood. Catalogs available. **Kitchen cabinets.**

AMERICAN OLEAN TILE CO.
1000 Cannon Avenue
P.O. Box 271
Lansdale, PA 19446-0271
(215) 855-1111

Large and widely distributed manufacturer of quarry tile in many colors, sizes, and thicknesses for floors, walls, and counters. Catalogs available to distributors, architects, and builders. **Tile floors, kitchens, baths.**

AMERICAN-STANDARD
P.O. Box 6820
Piscataway, NJ 08855
(800) 821-7700

One of America's most widely distributed manufacturers of bath and kitchen fixtures. Catalog available. **Kitchen and bath fixtures.**

ANDERSEN CORPORATION
100 Fourth Avenue North
Bayport, MN 55003-1096
(612) 439-5150

The Andersen Corporation has been making windows and glazed doors for eighty-five years. They have residential and commercial lines. Both are available in such options as Flexiframe, custom-made windows to fit any shape and size; and Perma-Shield, long-lasting and low-maintenance windows. Catalogs available. **Doors, windows, skylights.**

ANGLO-AMERICAN BRASS CO.
P.O. Box Drawer 9487
San Jose, CA 95157-0792
(408) 246-0203

Manufacturers of a very extensive line of brass hardware in a large variety of antique styles. They make hooks to hang pictures from Victorian-style picture molding. Brass screws and cabinet hardware are also available. Custom castings can be made in large quantities or single duplicates. Showroom and catalog. **Exterior hardware** (limited selection), **interior hardware.**

THE ATRIUM DOOR & WINDOW COMPANY
P.O. Box 226957
Dallas, TX 75222-6957
(214) 634-9663

A selection of windows and glass doors with wooden frames. They also offer brass locks with lockset options. Windows and doors are insulated and designed to fit a variety of needs. Catalog available. **Doors, windows, exterior hardware.**

BALL AND BALL
463 W. Lincoln Highway
Exton, PA 19341
(215) 363-7330

A manufacturer of traditional hardware reproductions for doors, shutters, and furniture of all historic American periods, brass and iron hinges, knobs, etc. They stock a very large selection, but will also do custom work to match existing hardware or new design. Their showroom and hardware museum near Philadelphia displays their full line of hardware, lighting, and accessories such as andirons and trivets. Catalog available. **Exterior hardware, interior hardware, lighting.**

BENDIX MOULDINGS, INC.
235 Pegasus Avenue
Northvale, NJ 07647
(800) 526-0240
(201) 767-8888

Manufacturers of hardwood, metal, and plastic moldings, including pilaster moldings and beaded ornaments. Separate catalogs are available for metal-covered moldings and finished or unfinished picture-frame moldings. Custom work with a minimum order of approximately a thousand feet. Catalog available. **Moldings.**

CARLISLE RESTORATION LUMBER
Route 123
Stoddard, NH 03464
(603) 446-3937

Manufacturers of select wide-board pine and oak in widths and thicknesses that will match the boards in many old buildings. Free brochure. **Walls, wood floors.**

CARRIAGE HOUSE
Route 501
Schaefferstown, PA 17088
(717) 949-2114

Manufacturers of all-wood custom-made cabinetry in a variety of finishes. Cabinetry is made of solid woods such as oak, birch, cherry, and walnut. All cabinets have a full year guarantee. Catalog available. **Kitchen cabinets.**

A. J. P. COPPERSMITH & CO.
20 Industrial Parkway
Woburn, MA 01801
(617) 245-1223

Manufacturers of antique-style indoor and outdoor lighting in a variety of finishes: copper, brass, pewter color and verdigris. All are sold electrified, although it is possible to order partially or completely candle-lit fixtures. Lampposts, mirrored sconces, and brass candlesticks are also stocked. Catalog available. **Lighting.**

CUMBERLAND WOODCRAFT CO., INC.
P.O. Drawer 609
Carlisle, PA 17013
(800) 367-1884
In PA (717) 243-0063

An extensive line of Victorian-style millwork in hardwoods. For exterior decoration, they have many patterns of corbels, brackets, etc., as well as all sorts of decorative elements, moldings, staircase parts, and paneling for interiors. Their oak lattice can be custom-framed for interior screens or garden dividers. Custom work. Catalog available. **Porches, walls, moldings, stairs.**

DRIWOOD
P.O. Box 1729
Florence, SC 29503
(803) 669-2478

Producers of wooden moldings and millwork. Their styles can be combined in innumerable ways to make up mantels in virtually any style or size desired. Custom work. Catalog available. **Walls, moldings, stairs, fireplaces.**

ELJER PLUMBINGWARE
901 Tenth Street
Plano, TX 85086-9037
(800) 988-1030

Nationally distributed manufacturers of bathroom fixtures with matching tile available. **Bathroom fixtures.**

ELON TILE
642 Sawmill River Road
Ardsley, NY 10502
(914) 693-8000

Imported handcrafted ceramic tile for counters, walls, and floors. Brochure. **Tile floors, kitchens, baths.**

HOSEK MANUFACTURING COMPANY, INC.
4877 National Western Drive, Suite 205
Denver, CO 80216
(303) 298-7010

A family firm that makes all ornamental plasterwork from old molds which have been in the family for generations. They make ceiling medallions and cornices as well as entire ceilings cast from English Stately Home originals. Fireplaces and exterior columns are made in fiberglass-reinforced gypsum which can be sealed to look like marble. Custom work. Catalog available. **Ceilings, moldings, fireplaces.**

KEMP & GEORGE
9180 Lesaint Drive
Fairfield, OH 45014
(800) 343-4012

A mail-order firm offering an extensive collection of high-quality home decorating items in traditional and contemporary styles, ranging from lighting and bath accessories to decorative hardware, faucets, sinks, and much more. **Exterior door hardware, ceilings, moldings, lighting, kitchen and bath sinks, bath hardware.**

KENMORE INDUSTRIES
One Thompson Square
P.O. Box 34
Boston, MA 02129
(617) 242-1711

Manufacturers of fine wooden carved doorways in Federal, Adam and Georgian styles. There are fifteen different doorways, all produced in solid mahogany. The doors are fairly elaborate in style but relatively simple to install, as they are usually shipped in six sections. Kenmore makes carved overdoors in designs such as Gothic half-round and a historic dolphin carving. Some doors can be adapted for use as windows. Custom work can be done, but only for large quantities. Free brochure and catalog available. **Exterior doors, windows.**

KENTUCKY WOOD FLOORS
4200 Reservoir Avenue
Louisville, KY 40213
(502) 451-6024

Suppliers of an extensive variety of floors. The woods that are available are as extensive as their floor designs. Their catalog has many styles and colors, including the floor they made for the Oval Office of the White House. Any style or combination of woods made to order. A large network of distributors around America and abroad. Catalog available. **Wood floors.**

KOHLER CO.
Highland Drive
Kohler, WI 53044
(800) 4 KOHLER

One of the two largest (American-Standard is the other) manufacturers of plumbing fixtures in the United States. Catalog available. **Kitchen and bath fixtures.**

MAD RIVER WOODWORKS
P.O. Box 1067
189 Taylor Way
Blue Lake, CA 95525-1067
(707) 668-5671

Producers of shop-sanded, ready-to-finish millwork crafted in the Victorian style. Catalog available. **Porches, moldings, stairs.**

MARVIN WINDOWS
Warroad, MN 56763
(800) 346-5128
In MN (800) 552-1167

Wood-framed windows and glazed doors. They offer a large number of styles and options. Catalog available. **Doors, windows, skylights.**

MERILLAT INDUSTRIES, INC.
P.O. Box 1946
Adrian, MI 49221
(800) 624-1250

Makers of over two hundred different sizes of cabinets for the kitchen and bathroom. They offer a wide range of finishes and woods at affordable prices. Catalog available. **Kitchen cabinets, bathroom cabinets.**

NATIONAL DOOR COMPANY, INC.
5 Sumner Place
Saranac Lake, NY 12983
(518) 891-2001

This company specializes in quality wood panel doors available in a large selection of woods. They also manufacture architectural components, such as side and over lights, and rail and stile wall paneling. They do custom designs, reproductions and restorations, and glass panels. Also an extensive collection of stock designs. Free color brochure. **Exterior doors, windows, moldings, interior doors.**

PLEXACRAFT PRODUCTS, INC.
5406 San Fernando Road
P.O. Box 3722
Glendale, CA 91201
(818) 246-8201

Plexacraft is a group of decorative hardware companies serving both decorative and functional purposes. Its three divisions are Plexacraft (door hardware using Plexiglas), Crafts Metal (solid brass cabinet, bathroom, door, and furniture hardware in traditional styles), and SECO (handcrafted hardware in authentic antique styles). Custom work. Catalogs available for all three companies. **Exterior and interior hardware.**

POGGENPOHL USA CORP.
5905 Johns Road
Tampa, FL 33634
(813) 882-9292

Manufacturer of Eurostyle kitchen and bath cabinets. Catalog available. **Kitchen and bath cabinetry.**

PROGRESS LIGHTING
Erie Avenue and G Street
Philadelphia, PA 19134-1386
(215) 289-1200

The largest manufacturer of residential lighting fixtures in the United States, this company's products are very widely distributed. They have a small line of authentically decorated Victorian reproductions, and several Colonial-style chandeliers. Catalog available. **Lighting.**

THE RENOVATOR'S SUPPLY
Millers Falls, MA 01349
(413) 659-2211

Components geared toward Colonial and Victorian houses but suitable for a wide variety of styles. Prices are reasonable. Door and cabinet hardware, bath hardware, and lighting plus some fireplace accessories are among the items offered. Catalog available. **Exterior hardware, interior hardware, stairs, fireplaces, bath and kitchen hardware, bath sinks.**

RUTT CUSTOM KITCHENS
P.O. Box 129
1564 Main Street
Goodville, PA 17528
(215) 445-6751

Rutt makes custom-built kitchens, paying strong attention to appliance measurements and style detail. Catalog available. **Kitchen cabinets.**

SAN FRANCISCO VICTORIANA
2245 Palou Avenue
San Francisco, CA 94124
(415) 648-0313

Manufacturers of Victorian-style wood molding and plaster ornaments. The plaster ornaments include ceiling roses, cornices, swags, and capitals. Custom work in both materials. They also stock the Crown Anaglypta embossed wallcovering from England and have a stock of antique embossed wallpaper borders made in Germany between 1892 and 1914. Catalog and sample packets of wallcoverings and borders available. **Ceilings, walls, moldings.**

SHEPPARD MILLWORK, INC.
21020 70th Avenue West
Edmonds, WA 98020
(206) 771-4645

A mostly custom woodwork company which stocks some patterns of molding. The emphasis is on Victorian style. Mantelpieces, doors, and stair parts made to order, and existing millwork matched. Free brochure. **Molding, interior doors, stairs, fireplaces.**

SIEMATIC CORPORATION
P.O. Box F286
Feasterville, PA 19047-0934
(215) 244-0790

Eurostyle kitchen cabinets. Catalog of kitchen ideas and floor plans available. **Kitchen cabinets.**

SILVERTON VICTORIAN MILLWORKS
P.O. Box 2987
Durango, CO 81302
(303) 259-5915

A full line of moldings, door and window casings, and paneling, as well as plate rails which can be combined with other moldings. They carry many patterns of decorative siding and wood brackets. Custom work to order on special doors and windows, vergeboards, beading and fluting, and sawed ornamentation. Color catalog available. **Porches, exterior doors and windows, molding, stairs, fireplaces.**

SMALLBONE
A & D Building
150 East 58th Street
New York, NY 10155
(212) 486-4530

315 South Robertson Boulevard
Los Angeles, CA 90048
(213) 550-7299

Handcrafted custom kitchens and baths in old pine and English oak. Also a wide assortment of hand-painted kitchens which are finished with decorative paint techniques such as dragging, rag-rolling, stippling, and sponging. Color catalog available. **Kitchen cabinets, bath cabinets.**

W. P. STEPHENS LUMBER COMPANY
22 Polk Street
P.O. Box 1267
Marietta, GA 30061
(404) 428-1531

Manufacturers of moldings, specializing in custom architectural millwork. They will match existing elements, and make entire paneled rooms, cabinets, and spiral staircases as well as many styles of doors. Both hardwoods and paint-grade lumber used. Catalog available. **Exterior doors, walls, moldings, interior doors, stairs, fireplaces, storage.**

SUNSHINE ARCHITECTURAL WOODWORKS
Route 2
Box 434
Fayetteville, AR 72703
(501) 521-4329

Sunshine offers a full line of paneling and molding in hardwood. The standard wood is poplar, but many other fine woods are available. All paneling is made to order, and the

moldings can be combined to make stacked cornices or mantelpieces. Catalog available. **Walls, moldings, stairs, fireplaces.**

TIRESIAS, INC.
P.O. Box 1864
Orangeburg, SC 29116
(803) 534-8478

Longleaf pine boards for flooring and paneling. They mill the timbers and make beams and mantels as well as floor-boards. Most of the timbers are old, but new pine and other fine woods are also milled. Custom work. Free brochure. **Moldings, wood floors, fireplaces.**

VELUX-AMERICA INC.
P.O. Box 3268
Greenwood, SC 29648-9968
(803) 223-3149

Makers of roof windows and skylights. They also offer sun-screening accessories and convenience controls for quick and easy operation. Velux home windows are available through lumberyards and home centers. Brochure available. **Windows, skylights.**

VINTAGE WOOD WORKS
513 South Adams
Fredericksburg, TX 78624
(512) 997-9513

Manufacturers of authentic Victorian gingerbread and other interior and exterior pine designs. Vintage Wood Works makes all the components for gazebos and porches. The gazebo is shipped as a kit for do-it-yourself assembly. Shingles suitable for walls and roofs also available. Custom work. Catalog available. **Porches, shingles, moldings, doors, stairs.**

WOOD-MODE
Kreamer, PA 17833
(800) 635-7500

Nationally distributed kitchen cabinets in a large range of styles. Free brochure. **Kitchen cabinets.**

WOODSTONE
The Woodstone Company
Patch Road
P.O. Box 223
Westminster, VT 05158
(802) 722-4784

A custom architectural millwork company with its primary focus on the manufacturing of high quality windows and

doors. Specializing in period reproductions, they use the finest grades of lumber available and take great pride in their pegged mortise and tenon joinery. Many glazing options, including insulated glass and Low-E glass. Custom work only. Brochure available. **Exterior doors, windows.**

Appendix *Magazines and Books*

The many widely available magazines and books on the subject of home design are a useful source of ideas about architectural details and how to use them. It's a good idea to clip articles and pictures which represent some factor of decoration which appeals to you. Seeing, for instance, moldings or skylights in a furnished room setting will help you decide how to improve your own living space.

Some of the most widely distributed home magazines are:

Architectural Digest
HG (House and Garden)
House Beautiful
Metropolitan Home
Home
Colonial Homes
Country Living
Country Home

Specialized magazines such as *Fine Homebuilding, Old-House Journal* and *Historic Preservation* show many interesting houses. Most cities and areas today have publications concentrating on local buildings. *Southern Living, Southern Accents, Sunset,* and *Texas Homes* are excellent examples.

In Canada, some leading decorating magazines are:

City and Country Home
Canadian House and Home
Select Homes
Western Living
Decormag
Toronto Life Homes

Books on architecture and home decoration are being produced at a great rate, and most have something to offer. A library or design-oriented bookshop is the best place to review these books before buying, as most are expensive. The books below are some, but by no means all, that we have found helpful.

A useful architectural reference is Cyril M. Harris's *Dictionary of Architecture and Construction,* published in paperback by McGraw-Hill. It gives brief definitions of common technical terms, geared to the layman. If you are curious about how a building is actually put together,

Francis D. K. Ching's *Building Construction Illustrated,* also in paperback from Van Nostrand Reinhold, is a good introduction.

The exteriors of American houses are comprehensively cataloged in *A Field Guide to American Houses,* by Virginia and Lee McAlester, published by Knopf. More detail-oriented and equally valuable is *American Vernacular Design 1870–1940,* by Herbert Gottfried and Jan Jennings, also published by Van Nostrand Reinhold.

Period Details by Martin and Judith Miller, published by Crown, shows hundreds of interior and exterior details of traditional English and American houses. *Authentic Decor* by Peter Thornton, published by Viking, and *An Illustrated History of Interior Decoration* by Mario Praz, published by Thames and Hudson, are two lavishly illustrated texts about historic interiors. *Interior Visions: Great American Designers and the Showcase House* by Chris Casson Madden, published by Stewart, Tabori and Chang, shows how leading decorators put rooms together.

The Old-House Journal Catalog, which is updated yearly, is a comprehensive source directory for all the components of a house. Architects use *Sweet's Catalog,* a looseleaf compendium of manufactured products, to keep up with what is on the market. A good library will have a copy.